Stayin' Alive Ain't No Jive

Charles Vance

Heart Thoughts Publishing
Floyds Knobs, IN

Stayin' Alive Ain't No Jive Copyright © 2017 by Charles Vance

All rights reserved. This book or any portion thereof may not be reproduced or used in any manner whatsoever without the express written permission of the publisher except for the use of brief quotations in a book review.

The names of the people in this book have been changed to protect privacy.

Printed in the United States of America

First Printing, 2016

ISBN-13: 978-1542922937
ISBN-10: 1542922933

Heart Thoughts Publishing
P.O. Box 536
Floyds Knobs, IN 47119

ACKNOWLEDGEMENT

This book is not just about me, but the ones who came through the school of hard knocks. It wasn't easy growing up for any of us. But if you made it this far, pass wisdom to the next generation.

To all who stood by me, 1 love...day 1 peeps, 1 love...low end peeps, 1 love...north side, 1 love Milwaukee, 1 love...Zion, 1 love...Africa, 1 love. Let's keep this love flowing...peace.

Thank You Father...Family...Friends...Associates, without you I'm nothing but an illusions...1 Love. Don't lose the feeling we share!

Table of Contents

ACKNOWLEDGEMENT ..3

Chapter 1: GHETTO CHILD ..7

Chapter 2: ART, MONEY AND MATH..............................10

Chapter 3: GHETTO EDUCATION13

Chapter 4: LADY HEROIN ..16

Chapter 5: SO STUPID-MINDED..................................19

Chapter 6: CONFLICT ...21

Chapter 7: TOUCH DOWN ...24

Chapter 8: A HOLY INTELLECT26

Chapter 9: RESTLESS NIGHTS29

Chapter 10: FRESH START ..32

Chapter 11: CANCER, CHEMO AND ME.........................35

Chapter 12: MAGNIFII PEACE37

Chapter 1: GHETTO CHILD

Charles Vance, A.K.A. Mink, Robert Taylor made, born and raised. I was the 10th of 11 children (5 brothers and 5 sisters). All under the same roof at one time, 4 rooms with 11 kids, it was never a peaceful moment back then. There was never a dull moment in my house. And, to top it all, my mother with her budget didn't mind raising other kids. It wasn't easy but we managed to get through the good, the bad and the ugly.

Most of us had different daddies. I never met mine; he passed away when I was a baby. So basically, there was no father figure around my house. My sisters, Doris and Marsha cared for me while my mother was busy doing her thing.

Around the age of 11, mom cleaned shop. She started studying with some Jehovah Witnesses and everything changed at home quickly. Most of my older siblings cut out and the youngest were still

under Mom's roof. Though some things did change, we were still poor. Now a Jehovah Witness in the house and a moral lesson every day. Mom would make us go to the Kingdom Hall every week and certain days of the week we had to study the Bible. My friends use to make fun of me for knocking on their doors early on Saturday mornings...they roasted me bad. I use to hate doing it, but I had no other choice. "YA'LL BETTER LEAVE ME ALONE, LOL". However, I loved those Bible lessons, I loved reading them. The stories intrigued me, but I was already predisposed by another element around me and I just didn't have that father figure to balance me out.

Growing up in the projects you had to learn fast and think fast in order to keep up. There was so much game going on around me, I didn't know what was real and what paradox was. It was hard trying to distinguish who was lying or telling the truth. This was some real action type shit. The players were real, the pimps were real, the hookers were real and the hustlers were all real. "Point seen, money lost...Get in where you fit in." Time to hustle at eleven, I tried on my first mask, didn't feel bad either. In a way, it felt like I was a part of something. But the darkness of a con man is living

a lie and never the less there is a lesson to be learned...BUCKLE UP LIL CHILD, THE GAME AWAITS YOU!!

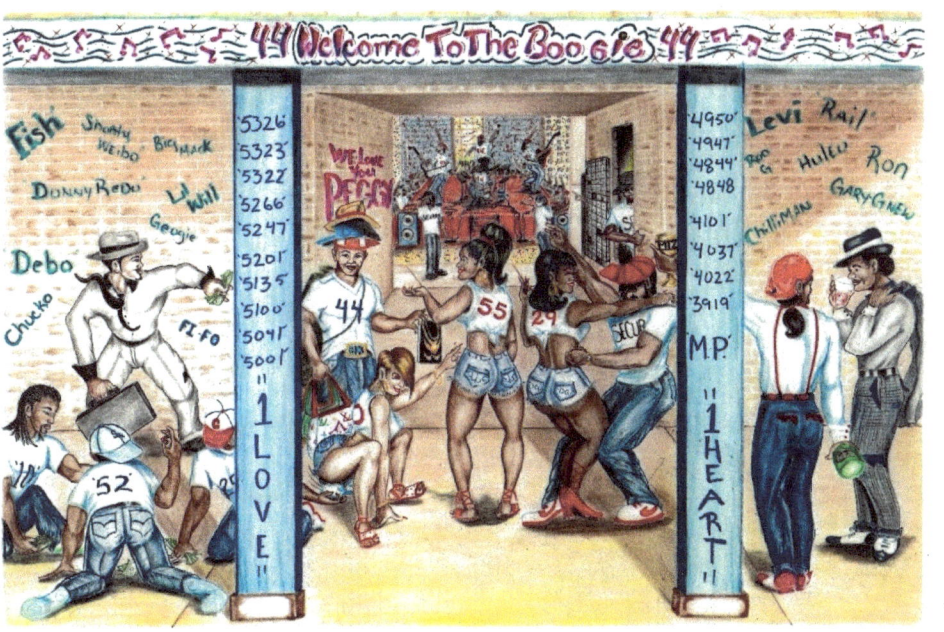

Chapter 2: ART, MONEY AND MATH

Rest in peace Ernie Barnes, Bob Ross and Salvador Dali. When I was younger, I loved these particular artists because they were magical with the brush. Bob Ross was so fast with it, it didn't make sense. He completed oils in less than 30 minutes, incredible! Then you have Ernie Barnes, that cat who did the funky paintings for Marvin Gaye album cover, "Sugar Shack." He kept it funky. Then we have Salvador Dali, an outright magician with the brush. His surrealness was off the chain and it stirred the imagination. There were other great artists I admired, but these three stood out the most. If I could come close to their ability I would be fine.

At the tender age of 11, I was drawing something like them. I was determined to be famous one day. Back then, I remember trying to win this contest from Esquire Magazine that featured little furry animals. Caption read, "DRAW ME," and win

$10,000 or a school scholarship. I wasn't paying no attention to no scholarship, I needed the bread, "you feel me." I drew the picture and they sent offers for school, but I was only 11, I wanted the bread, "send me my money." Hell, I drew the picture just like they said. They didn't bother tho. You see, I thought they didn't believe me, so I drew three different animals. You had to be 16 and I was only 11 years old. A dream deferred...Oh well, gotta get it another way! But I learned a great deal about drawing from those characters. I was already drawing superhero characters; these new drawings would only add to what I had done already. Focusing the eye took a lot of concentration. Math also plays a big role with the 2 and 3 dimensional objects.

I never had a problem with math because I always equated it with money. If it didn't make money, it didn't make sense. My cousin Paul and I, would stay up all night talking about how we were going to be millionaires one day and make a difference in the world we live in. I'M NOT A MILLIONAIRE YET, BUT FATHER TIME IS ON MY SIDE!

Chapter 3: GHETTO EDUCATION

Now I'm of age, wearing hand me downs, sleeping on pissy mattresses and faced with gangs. My lil' brother, nephew and I were close in age. We would hang together to keep the bullies at bay. We played little league baseball in the summer, football and basketball in the winter. In order to pay for uniforms and equipment, we would collect pop bottles, hustle aluminum cans, or help seniors with their groceries, walk your dog and pet your cat. Because I was the oldest the pressure was always on me to lead. Being crafty was just me. I always came up with ideas to make money. I hated being teased by guys who were my age about my clothes, so I had to do something about that, I thought. I started making hats from fur coats. That's how I got the nick-name "Mink." I started making and selling hats to the older guys..."Shawty Mink Dawg" is what they called me.

One day I was coming home from the Thrift Store

on 43rd and Indiana, and these guys approached me, *"Who you ridin' with homie?"*

I said, *"Nobody."*

One of the guys knew me from playing little league and shouted, "*That's that Nicca from the projects*"....next thing I know we brawlin. They puttin' the fu-fops on me, but I never go down.

Then outta nowhere I hear a familiar voice screaming, "*Get the fuck off him.*" It was my friend, Fish coming to help me with a baseball bat and throwing bricks at them. I got loose and ran toward Fish happy as hell. He saved me from a beat down. Friends for Life...R.I.P. my brother! I thanked my man Fish, who was a GD (Gangster Disciple), now I'm a GD, my life just changed in a blink of an eye. It's funny how life feels this way...hustling cans, pop bottles, helping with groceries was a thing of the past...TIME FOR SOME REAL ACTION, 14 going on 40.

'Oh-is-She'... Mie...a... The BlKSon

Chapter 4: LADY HEROIN

As I stated earlier, game was all around me, Pick-Pocketers, Boosters and Stick-up kids. My 8th grade teacher still had faith in me. He would always remind me if I didn't get it together, I was going to either end up in jail or dead. He was half right. I still graduated with honors. I scored very high on my Iowa Test in mathematics. Mr. Reid said they changed the test after this ghetto kid scored so high. He brought out the mathematician in me. I was good in math already, but he would give us drills and I would always win. He made school fun...thanx!!!

Pops Smiley on the other hand made the dem' numbers real. He was my sister's boyfriend, easy breezy, my man. I started smoking weed by now, knockin' off small licks here and there. My uncle once told me, "A black man with no money ain't shit but a nigga, and money don't see no color, if you got it, you somebody." I can dig that. Time was

flying and the year of 86' was a strange one.

The hustle was ok, but we experienced a major weed drought. All I saw was this crazy looking white guy named Max-Headroom talking about catch the wave...Coke! It was Coke alright, Crack had hit hard that year. I didn't like coke; me and my guys did that heroin. It wasn't long before we started selling drugs on a small scale. It was ok until my habit begins to show. Smiley saw what was going on and gave us a lesson on real hustlin'. I never saw so much money coming in so fast. We ate good for a minute, that's until I started catching all these cases. I had to fall back on Smiley, the police knew me way too well. Damn! This Jones (habit) don't understand, "Stop 'em, Sick 'em." TIME TO TRY SOMETHING NEW!!!

Chapter 5: SO STUPID-MINDED

Time to run up on a Rhino. Problems are piling up, cases are piling up, bills are piling up, and this jones (habit) is gettin' worse day by day. I got a girl I love desperately. I wanna change, but can't. I just don't know how to. I would go out of town for a couple of weeks and kick the habit and start all over again. I know there was some strength in me, but I was caught up in that life...so stupid-minded.

I'm in full hype mode now and it's starting to show. My family is worried, I'm outta control. Police are now trying everything to get me off the street as well as a few enemies I'd made mad along the way. We started robbing the people we once gang-banged against and when that played out, whoever was weak and got caught slippin' got a buck fifty from us. Just to get high, just to get by. It was as simple as that.

God help me, save me. My Momma stayed praying

for this stupid ghetto child trying to duck an early grave. Little did I know help was on the way in a different disguise. The Skool of Hard-Knocks is a reality check. Sheridan Correctional Center, here I come...TIME TO SERVE!!!

Chapter 6: CONFLICT

You asked for it, take it like a man. I finally got popped off by the police. I can't bond out. Mad as fuck, and stuck like chuck. I knew one day I would have to face these demons. For about a month or two I was still battling with this monkey on my back. With the help of a few guys who been through the same thing, I was able to kick that dreadful habit. Now that my head was clear, I was facing 3 counts of armed robbery and 2 counts of intent to deliver a control substance. I thought the judge was going to hit me with a life sentence, but he only gave me 8 years. I never had probation or any history of being on paper.

My first time in, I didn't know what to expect. But I heard being in the joint was far better than being in the county. Cook County was a mad house for real. Constant riots every month, gang fights, inmates getting robbed and shanked for their commissary. To make matters worse, there was a group of

correctional officers who were called 6-1. They would single you out and practically beat you down for nothing. I was surrounded by insanity. This isn't sexy at all.

I served 3 years and 9 months; I wasted a lot of time on foolishness. In the joint I had clout; my reputation on the streets preceded me. We had access to drugs and other things. Most of my time was spent telling war stories, gambling and smoking weed almost on a daily basis.

I passed my GED test without going to class. I knew the teachers well, so I convinced them to let me study a week in advance. They were cool with it and I passed. My GED was the only thing I achieved while I was in the joint.

The venom had run deeper than I could have imagined. I had gotten too comfortable with my lifestyle in the joint. I was receiving money from home and making money on the inside. TIME'S UP...I'M FREE, IN A SENSE AFTER WASTIN TIME!!!

Chapter 7: TOUCH DOWN

I'm really home, and everybody is happy to see. Seeing Mom's smile was like a breath of fresh air. My brothers and sisters were happy as well to see their lil' brother in one piece. We laughed, we cried. I really felt the love. The only face that's missing was hers. The one I fell in love with as a child, the one whom I longed for every night and sometimes throughout the day. We bumped heads a couple of times, but the magic was gone. We both grew apart...No hard feelings.

The first couple of months went well, but I knew my mind was still a product of the poison. That Genie still had me. The day I came home, I got high. I didn't know what the hell I was thinking, but I knew it wouldn't be long before I started poppin' wheelies (robbing) again, if I didn't find a job soon.

Sad to say, I didn't last 6 months on the streets. So stupid minded. I was caught in another armed

robbery, which got me 13 years this time. Now I'm really sick, this shit isn't cool at all. I cried that night in the bullpen alone and I promised that night that Genie would never get a hold of me again. From that moment on the next 25 years I kept my promise. I had burned most of my bridges in the joint and outside the joint. I was on my own this time with no support system other than my family...TIME TO HEAL!!!

Chapter 8: A HOLY INTELLECT

I decided to go to college for business management to further my education. But before I enrolled in school, I studied all the words in the dictionary like Malcolm X. I learned a great deal doing this first because it helped me understand diction and real English. I just couldn't seem to stay out of trouble. The first couple of years I stayed in trouble. I was fighting with the administrators, some punks or just myself. I still somehow felt a change coming over me. My instincts could tell that something was wrong. FOCUS MINK...FOCUS!

When I wasn't in class or studying, my mind would wander off to dreamland. The release felt good. I started reading all about world renowned artists, just to see what made them so famous and what inspired them. I stumbled across the Fibonacci sequence better known as the Golden Mean, and discovered that ratios could be found throughout the universe, in plants, the sea, the sky and even in art. The

fingerprint of God was all around us. This was one of the biggest eye-openers in my life. World History, Religion, Philosophy, Architecture and Mathematicians used this Sacred Geometry in one way or another. After finding this discovery, it seemed as if something kept calling me and wouldn't leave me alone. I spent endless nights looking out the window thinking about this.

I noticed my artwork getting better. I wasn't afraid to draw outside the box anymore. The genie was completely gone and I was free. From that moment on I understood my calling. "I'm an Artist, not a Gangster." It had always been with me even when I was in darkness. That's what God had been trying to show me and make me understand.

Slowly I started cutting ties with anything or anyone that hindered me. Surely I knew I was being tested...TIME TO BE MY FRIEND AND LET ME START AGAIN!

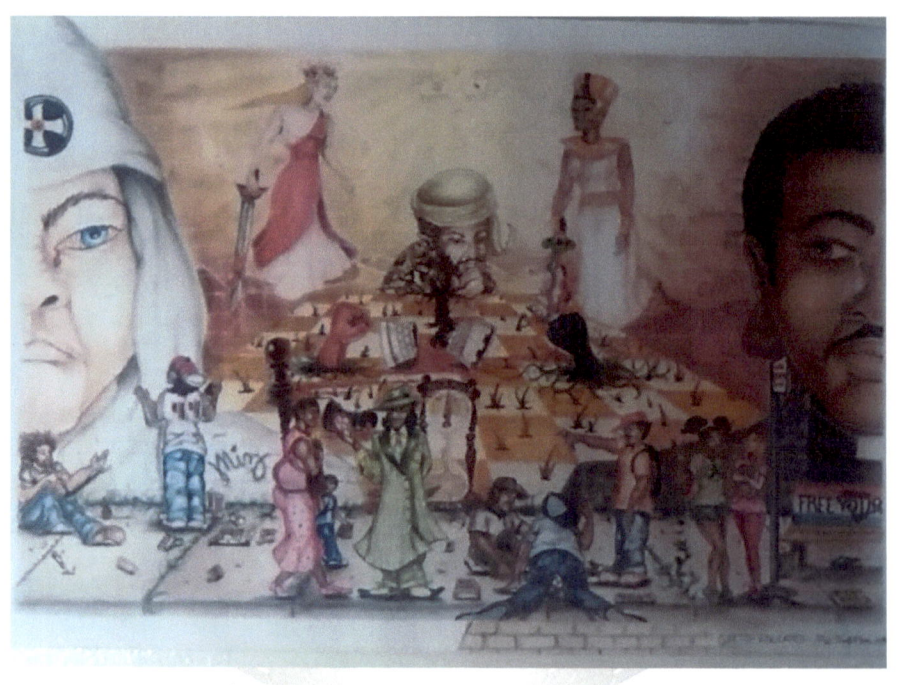

Chapter 9:
RESTLESS NIGHTS

Now the wizard had me. My mind was filled with so much information. I was ready to apply myself in the real world. I have come to learn the only difference between book knowledge and street knowledge was application; all knowledge came from a source to be written and broken down for you to learn.

I was in the belly of the beast and still required a great deal of humility. Most of these guys didn't care about nothin'; they would do anything to keep you in the pokey. I was Solo Polo with the exception of my brother Bolo. I had to keep my cool or catch another case or do more time and lose more time out. "Fuck that," I wanna be free! Say whatever you want, I was tired of that shit, isn't nothing sexy about that jail shit. I needed my freedom so bad; to live and explore this thing we call life. Dreams of visiting, Egypt, Paris, Africa and Puerto Rico, meeting new people, trying different foods, seeing

different cultures all excited me.

The last couple of years flew by so quickly, I could taste the world from here. I was coming home to a new world, new life and new beginning...HELLO BEAUTIFUL...HOW YOU DOIN'...CAN TIME BE OUR FRIEND, I PROMISE NEVER TO DESERT YOU!!!

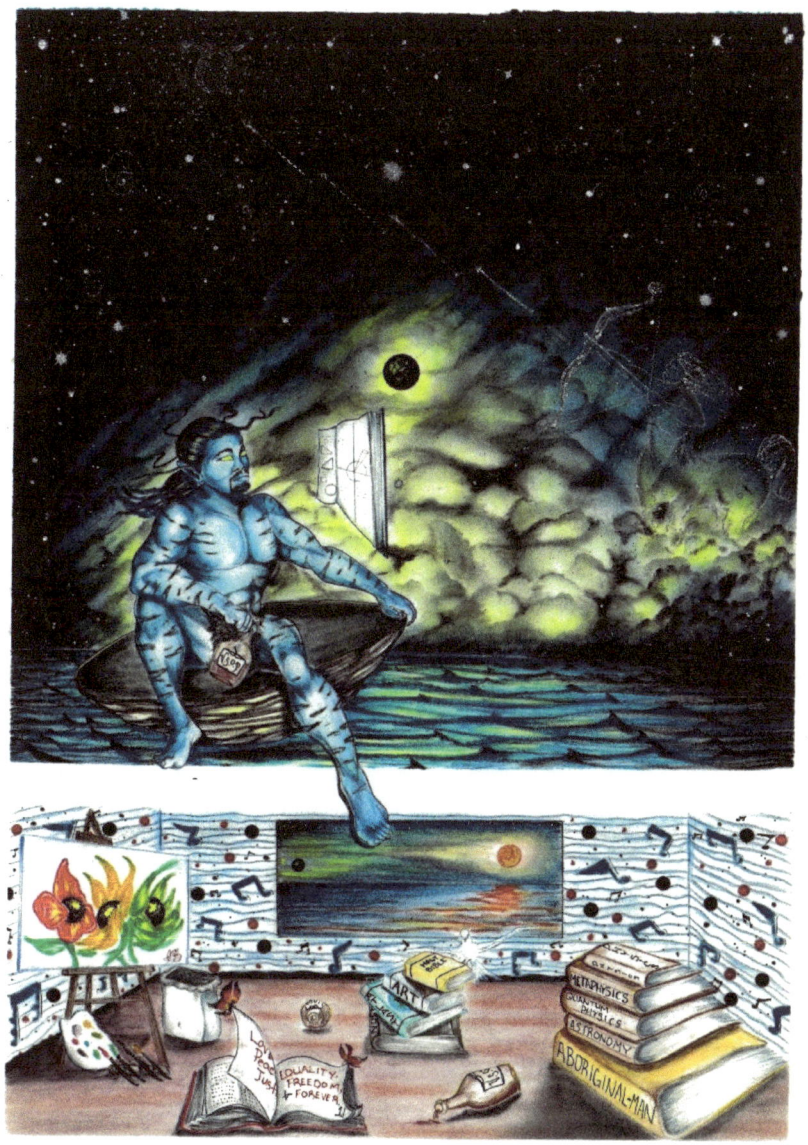

Chapter 10: FRESH START

A lot of bridges to repair and new ones to build. Gaining trust in people is important to ones' success or failure. Simply put, it's good when somebody has your back through hard times. I didn't waste any time looking for a job. My sister, Doris, gave me shelter and my brother, Keith, gave me money to get back and forth, Thanx Yall. I caught a break when my friend Nixx 21 helped me get a job on the North Side at a fish market cutting up fish. I moved up north to be closer to my job and ended up getting another job. I was hungry for life. God is good!

It was slow money, honest money, but for sure money and it felt good. In spite of my new found life, it was taking me away from my art. I would still produce, but I needed more time to focus on my collection. After a couple of years of all work and no play, I was able to save up enough money to visit the motherland Africa...a place that I dreamed

of.

What an experience! I am really living now. Africa is a real cultural experience, seeing it up close and personal, the whole world and its customs. They made me feel right at home, they welcomed me with open arms. Ethiopia is the birth place of mankind according to archeologists. I had to leave a mark there somehow...I didn't know it would be through marriage though. I had no idea I would end up with a wife. Yes..."I'z married now." This poor ghetto child just got married in Africa, wow! I had great hopes of starting a family and a good foundation. Although my marriage didn't last, there was a blessing out of all this, my beautiful baby girl was born into the world. More reason for me to get motivated. She is my Mini-Me and her foundation will be set one way or another.

Nevertheless, I had to experience life on its own terms. I got knocked around a little, but that's life. We all need that seasoning, take it like a man. Life is a procession of different things. I'm sure I will find love again.

There are a lot of good artists in this world, but if you have not been seasoned, you haven't really lived one bit. You can't appreciate how good life is

and how good God is. This is what makes an artist great...I UNDERSTAND TIME NOW!

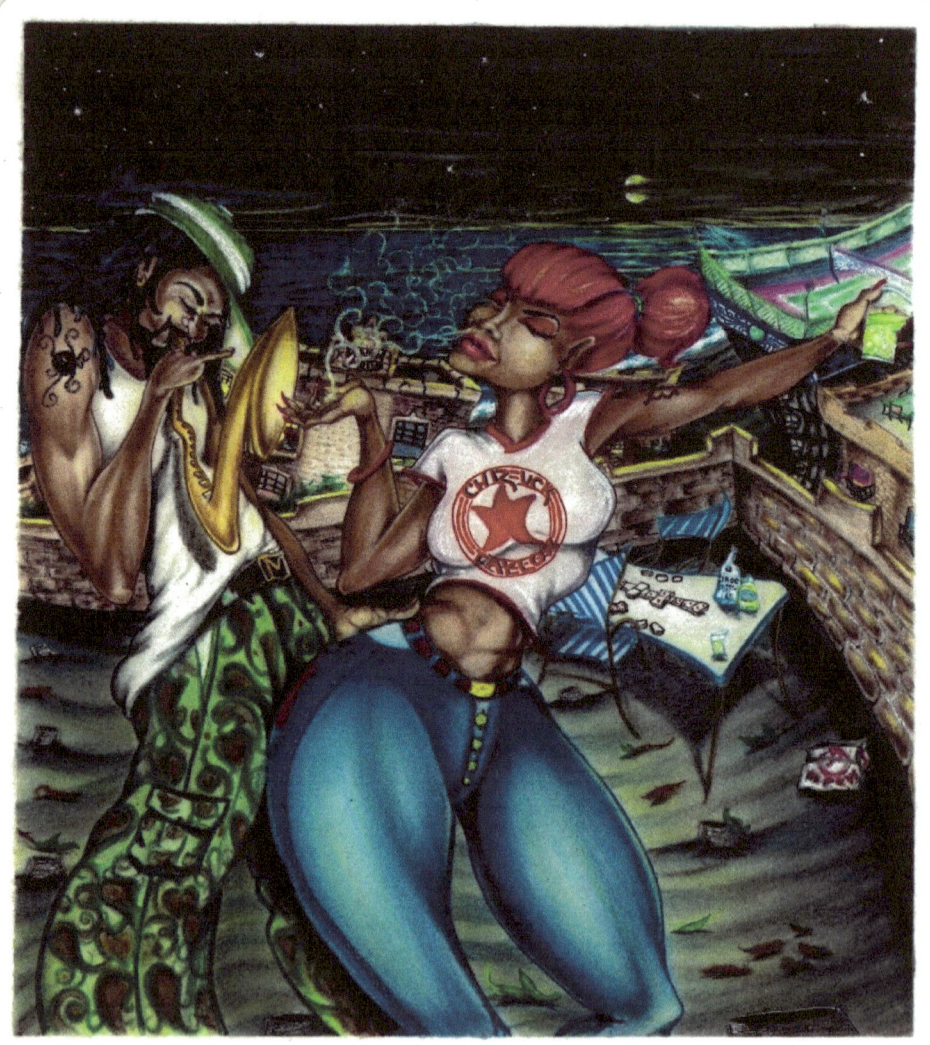

Chapter 11: CANCER, CHEMO AND ME

How did it come to this? This thing called life has its up and downs, ins and outs and entrances and exits. You can't be afraid of death. It's no getting around it, when it's your time...it's your time, it just wasn't my time to go.

In 2005 I was diagnosed with Hodgkin's Lymphoma. "Damn..." another fight along with my divorce and filing bankruptcy. Thank God I was able to catch it in its early stages. The only problem is that I hadn't created my body of work if I died. That haunted me. My daughter wouldn't know who I really was because she was still young. At this point nothing else really mattered. For the next three years, I snapped out, producing picture after picture. Before you know it, I had over 300 pieces completed.

I have lived, I have loved, and I have laughed,

gangbanged, danced, comforted, consoled and rejoiced in knowing I have made a difference in her life as well as her Godsisters' Deja and Helina. I, while living, have conquered the Universe. GOD IS GOOD...THANK YOU FATHERTIME!!!

Please, Father, Please... My... The 8th Sin

Chapter 12: MAGNIFII PEACE

Why do I promote peace? The answer is simple. When I looked at my babies and the world around them; I can't help but to go out of my way to keep them out of harm's way. This is my parental instinct. What parent doesn't want to see their children grow up into productive adults? We know it all takes a village to raise a child, but no one wants to take on the responsibility. I, Charles Vance, as an artist has taken on the task of raising awareness through my art. Some will listen; some will refuse to do so. The ones who will listen are the ones who are willing to make a difference. Why do we have to wait until something tragic happens to our children in order for us to address the issue? Let's take the time to deal with it before it happens again.

All cities don't deal with the same fatality rate. It seems to me it happens on a regular in the inner-city area, where the majority are African-Americans

and other minorities.

Self-hate is like the new norm. This cut-throat way of thinking is poisoning the minds of our children. How did it come to this? I often question myself; is it a lack of knowledge, resources or money? No! What is it then? I came up with the answer; it is a lack of awareness.

Understanding the problem is the first step to solving the problem. There are so many ways to rectify the problem, but if you're so busy getting "Turn't Up"...you lose focus on the practical solution. Some tend to enable their kids and send them out into the communities. My mother never let her kids deal drugs, guns, gangs, or any other vices. The things I did, I did in the street and I kept it in the streets. In no way could I bring that shit in my house. Even tho' we were poor, my mother was stern in our upbringing. I was the one who rebelled and made those choices.

I understand now that there is no perfect method to raising a child, but a good foundation will put a resolution in the child. As a child, they will make mistakes and will learn from the mistakes they make. Hopefully, they won't continue to make the same mistakes. Parents need to stop enabling

negative behavior. For example, why would I tell a young man in the streets of Chicago he "gotta keep shit Gangsta out here" after all I've been through? That's bad advice for a reckless teenager on the streets. I'm trying to help boys become men. Same for the women. Are you satisfied with raising girls who become whores or girls who grow to be productive women? We can do better if we stay focused. I'm not a saint but I am a man who went through some challenges in life. I've learned what it takes to be a man and do what a man have to do. This is why I'm telling you my story in hopes of reaching and teaching those who are struggling with the dark cons of men before my time runs out. 1 LOVE YA'LL...MAGNIFII PEACE NOT HATE!!!

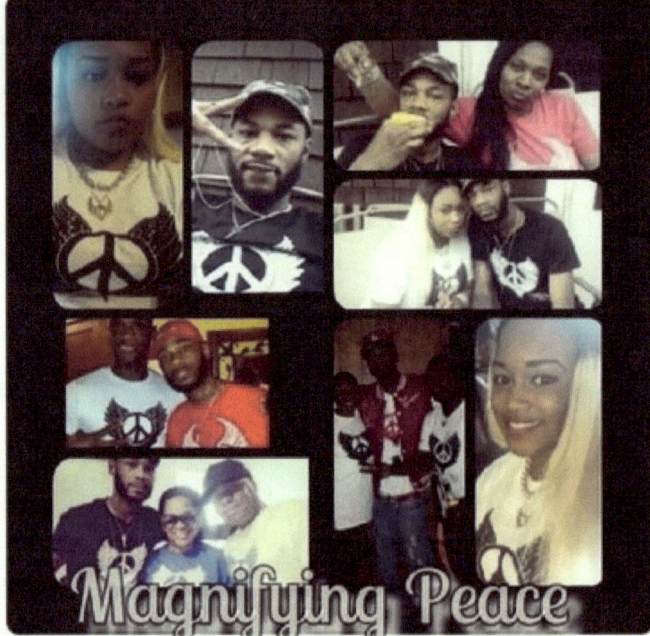

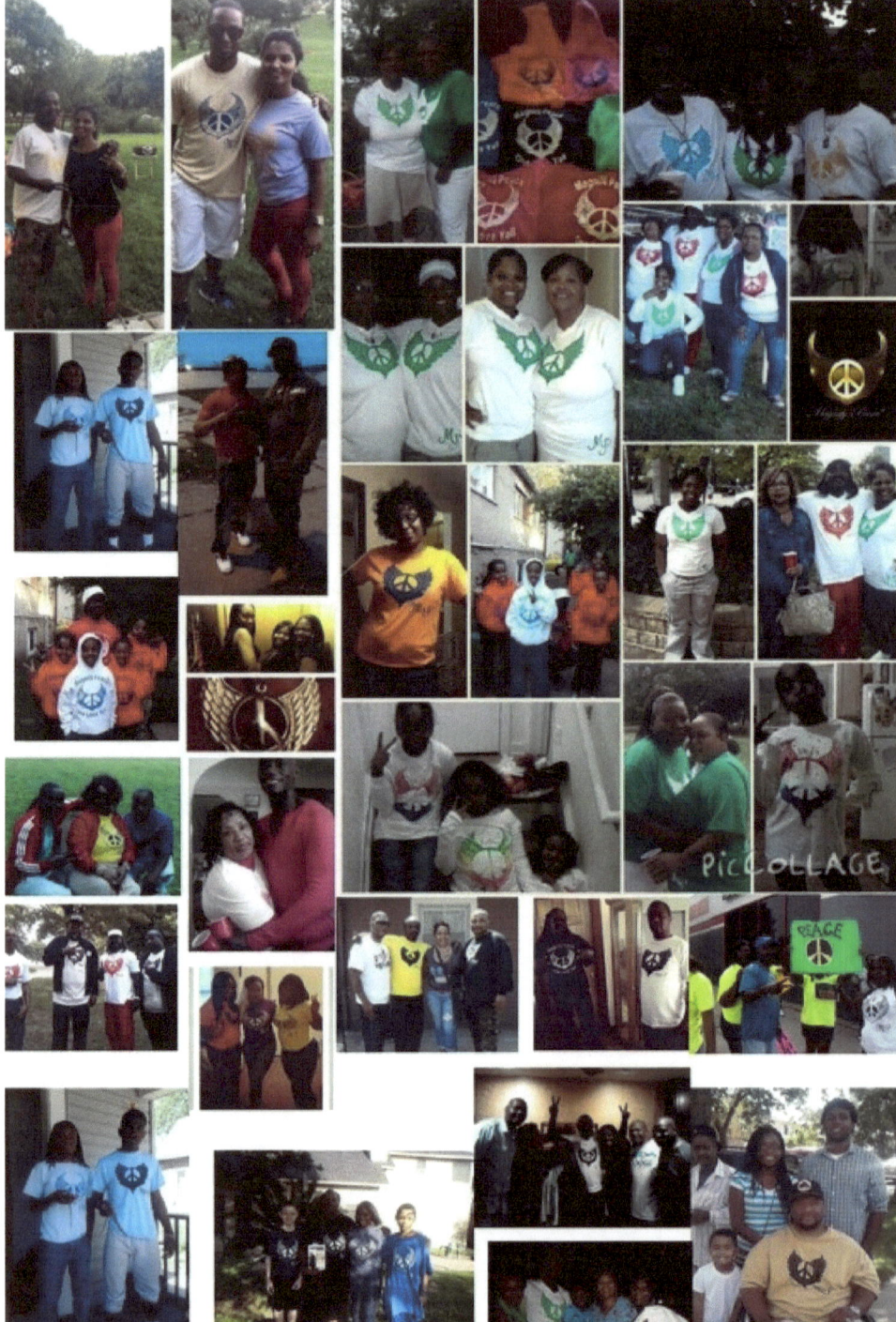

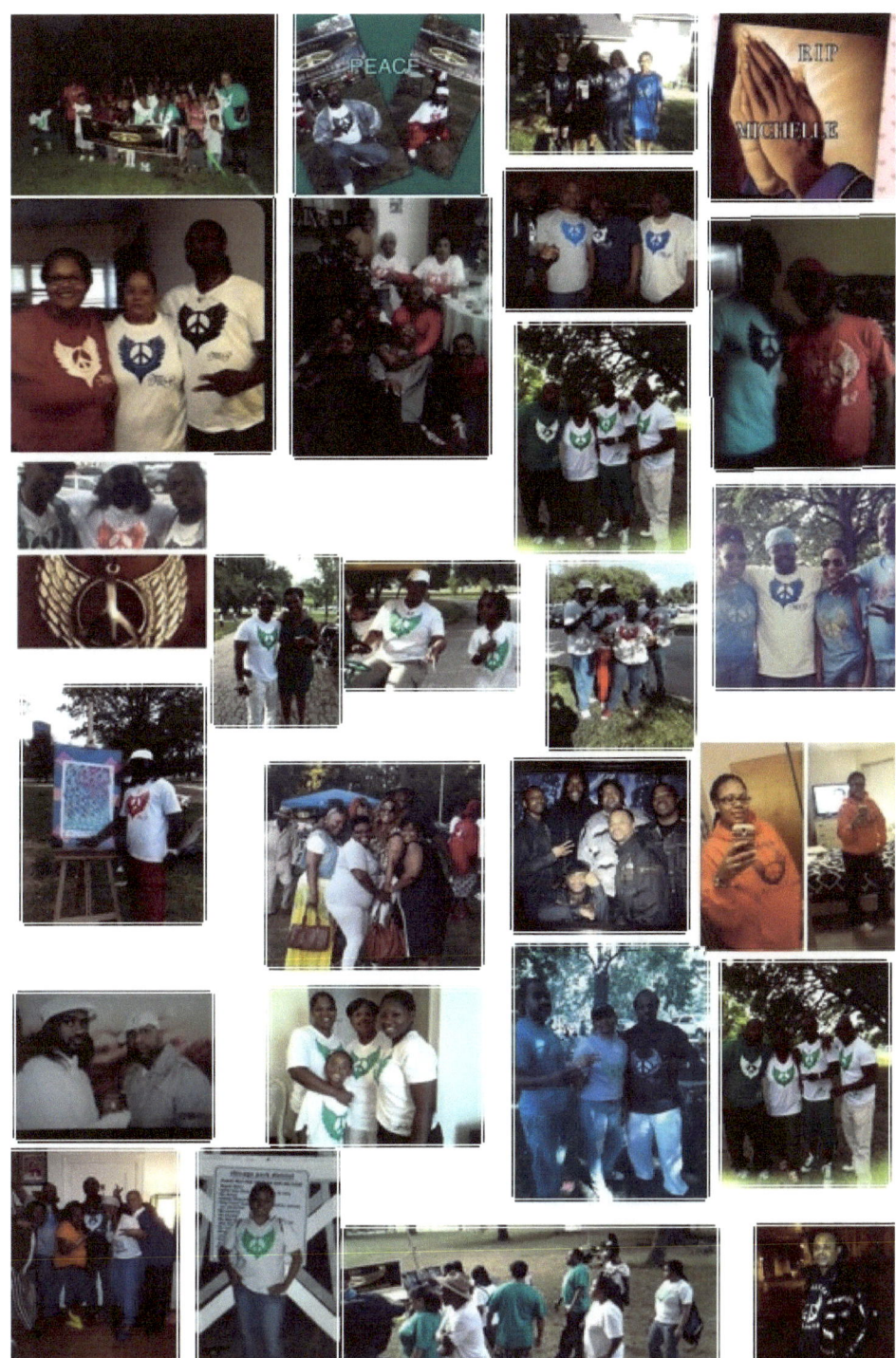

Other Books by Heart Thoughts Publishing

Intensive Faith Therapy – Vanessa Collins
The Promises of Jesus – Vanessa Collins
The Promises of God – Vanessa Collins
50 Mistakes Grant Writers Make – Vanessa Collins
Transcending Greatness – Lawrence Perkins
Lil Fella's Big Dream – Lawrence Perkins
Lupe and Kita – Lawrence Perkins
One Way – Dorsey Howard
The Start of a Healing Conversation – Edgar Gosa
Breakfast with God – Paul Jakes, Jr.
Pace Learns a Lesson – Cynthia Wilson
Every Day A Winner - By Aaron Gilbert
There's an Elephant in the Room – Cynthia Wilson
The Problem with Jesus – Aretha Tatum
Becky's Kidneys – Paulette Miles
From the Jewelry Box - Sheila Spencer
Moving From Religion To Relationship - Neisha-Ann Thompson
TJ and Randy's Big Weekend – Lawrence Perkins
Flatline Your Ego Mind - James Page
Jasmine's Big Secret - Lawrence Perkins
Fifty Shades of Faith – Stephanie Flores
Three Generations Cooking With Sole - Pamela Ward
Karissa's Amazing Invitation To Visit The Queen - Sharon Nelson
The Alphabets: El Alfabeto - Ari Armour
The Wonderful Counselor – Aretha Tatum
Some Good Things to Consider on the Way to See God - Derrick Collins
Finn The Freckled Fish – Antionette Reese
Enough: Say "NO" to Dieting - JoAnn Turner

Visit us at www.HeartThoughtsPublishing.com
Or email us at
Info@HeartThoughtsPublishing.com

www.ingramcontent.com/pod-product-compliance
Lightning Source LLC
Chambersburg PA
CBHW041111180526
45172CB00001B/203